Edward S. Curtis, 1899

Around the turn of the century, the American photographer EDWARD SHERIFF CURTIS (1868–1952) began to work on the monumental task of recording the North American Indians, a project which was to take him more than 30 years. These photographs, his life's work, were reproduced between 1907 and 1930 in a fine-quality, massive, 20-volume publication entitled *The North American Indian*. Combining both artistic commitment and scientific interest, he managed to capture the last living traditions of the Indians in words and pictures. He demonstrated great personal dedication in visiting some 80 Indian tribes, working his way systematically from the glaring heat of the Mexican border to the ice-fringed Bering Strait. With patience and sensitivity, he succeeded in gaining the Indians' trust. By this time, they had already been

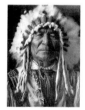

Sitting Bear – Arikara

herded into reservations. Their populations had been decimated to fewer than half of their original numbers, the result of wars, malnutrition and sickness, and in particular of the ongoing reduction of their living space. None of this, however, is reflected in Curtis' photographs. Instead, the images of feather-decorated Indians on horseback, of Indian squaws carrying water and the frame-filling images with expressive faces remind us more of the romantic aspects of the 19th century than of Curtis' own era, a time when on the one hand the Indians were fighting for their very survival and on the other hand the first automobiles wer̶ ̶ ̶ ̶ ̶ ̶ ̶ ̶ ̶ ̶ ̶ ̶ ̶ ̶ Curtis presents the Indians
and so helps restore
These masterly phot
and nature still seen

D1329245

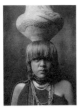

Girl and Jar –
San Ildefonso

Der amerikanische Photograph EDWARD SHERIFF CURTIS (1868–1952) begann um die Jahrhundertwende mit seiner 30 Jahre währenden Arbeit an einem Monumentalwerk über nordamerikanische Indianer. Unter dem Titel *The North American Indian* wurde sein photographisches Lebenswerk zwischen 1907 und 1930 in exzellenter Reproduktionsqualität als 20bändiges Werk veröffentlicht.

Mit künstlerischem Engagement und wissenschaftlichem Interesse hielt Curtis die Spuren des untergehenden traditionellen Indianerlebens in Wort und Bild fest. Bei Hitze und Kälte bereiste er unter großem persönlichen Einsatz systematisch das Gebiet zwischen der mexikanischen Grenze und der Bering-Straße und besuchte 80 verschiedene Stämme. Mit Geduld und Einfühlungsvermögen erlangte der Photograph das Vertrauen der Indianer, die bereits in Reservate

Yellow Kidney – Piegan

verwiesen worden waren. Ihre Zahl war durch Kriege, Unterernährung und Krankheiten, besonders aber durch die fortwährende Beschneidung ihres Lebensraums auf weniger als die Hälfte ihrer ursprünglichen Stammesgrößen dezimiert worden. Die Photographien spiegeln davon nichts wider. Die federgeschmückten Reiter, die wassertragenden Frauen und die ausdrucksstarken bildfüllenden Gesichter erinnern mehr an die Romantik des 19. Jahrhunderts als an Curtis' Zeit, in der die Indianerstämme ums nackte Überleben rangen und zugleich die ersten Autos vom Fließband liefen. Curtis zeigt die Indianer als Menschen von stolzer Haltung und edler Herkunft und gibt ihnen dadurch einen Teil ihrer einstigen Größe zurück. Die meisterhaften Photographien beschwören eine Zeit herauf, in der Mensch und Natur noch zu harmonieren scheinen.

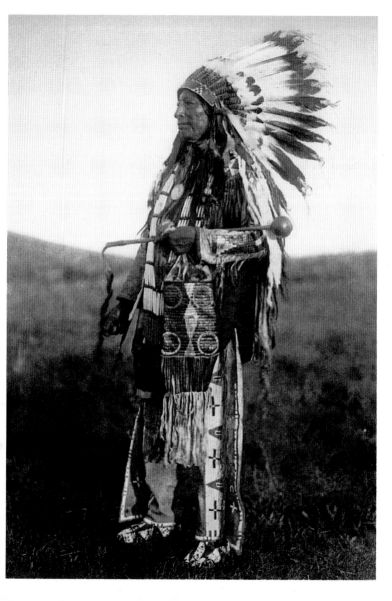

Edward S. Curtis
High Hawk
from the book:
THE NORTH AMERICAN INDIAN
THE COMPLETE PORTFOLIOS

TASCHEN

Edward S. Curtis
The Rush Gatherer – Kutenai
Die Binsensammlerinnen – Kutenai
La cueilleuse de joncs – Kutenai
from the book:
THE NORTH AMERICAN INDIAN
THE COMPLETE PORTFOLIOS

TASCHEN

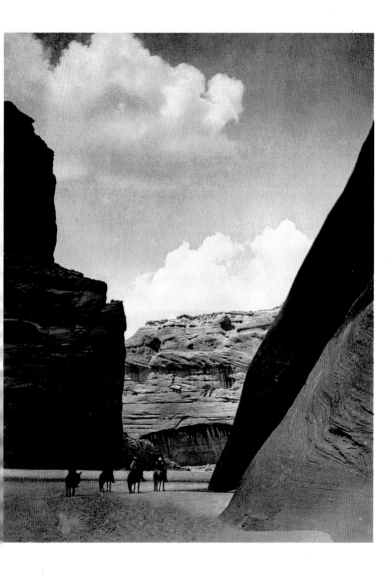

Edward S. Curtis
Cañon del Muerto – Navaho
from the book:
THE NORTH AMERICAN INDIAN
THE COMPLETE PORTFOLIOS

TASCHEN

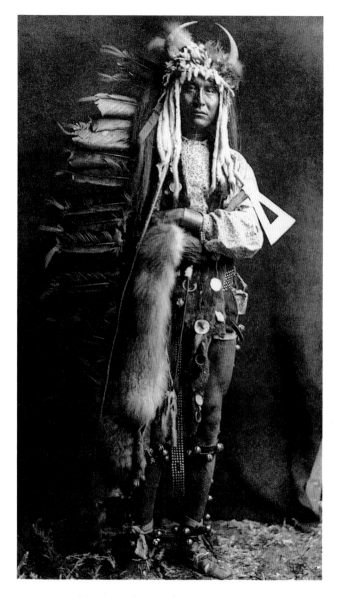

Edward S. Curtis
Iron Breast – Piegan
from the book:
THE NORTH AMERICAN INDIAN
THE COMPLETE PORTFOLIOS

TASCHEN

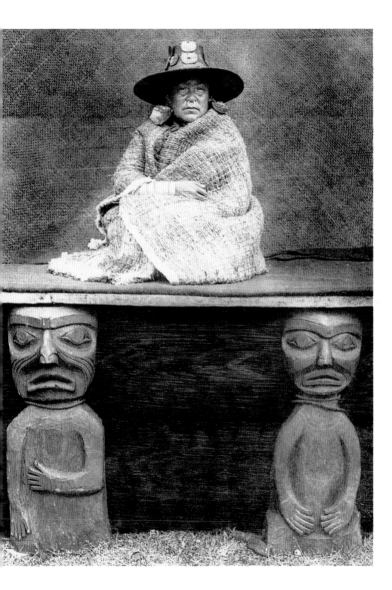

Edward S. Curtis
A Nakoaktok Chief's Daughter
Eine Häuptlingstochter – Nakoaktok
Fille d'un chef – Nakoaktok
from the book:
THE NORTH AMERICAN INDIAN
THE COMPLETE PORTFOLIOS

TASCHEN

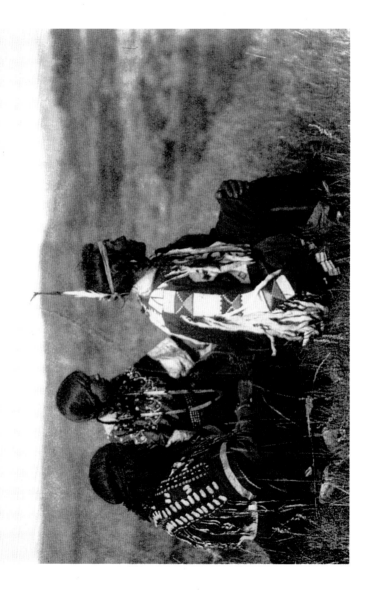

Edward S. Curtis
Overlooking the Camp – Piegan
Überblick über das Camp – Piegan
Vue sur le camp – Piegan
from the book:
THE NORTH AMERICAN INDIAN
THE COMPLETE PORTFOLIOS

TASCHEN

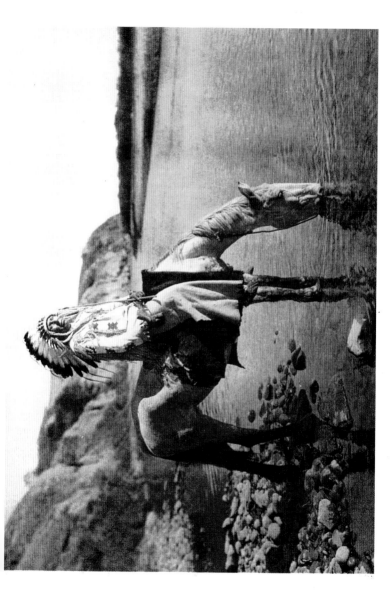

Edward S. Curtis
Bow River – Blackfoot
from the book:
THE NORTH AMERICAN INDIAN
THE COMPLETE PORTFOLIOS

TASCHEN

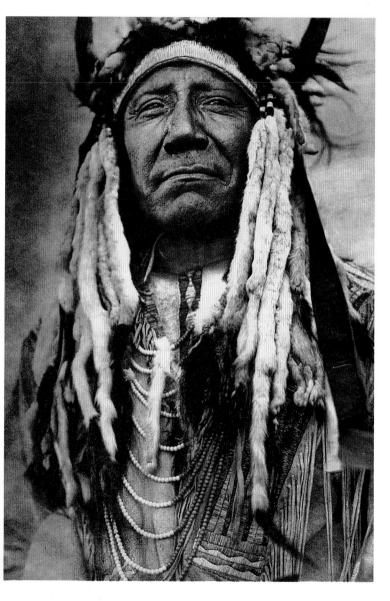

Edward S. Curtis
Two Moons – Cheyenne
from the book:
THE NORTH AMERICAN INDIAN
THE COMPLETE PORTFOLIOS

TASCHEN

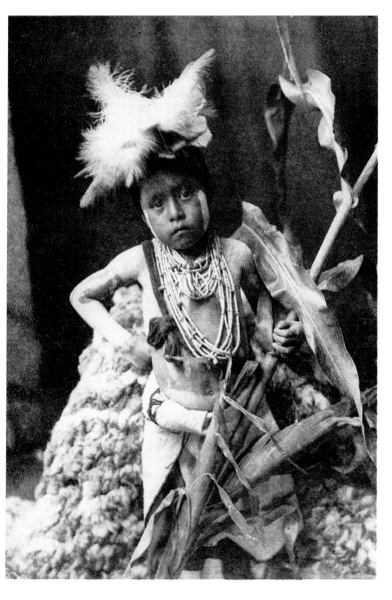

Edward S. Curtis
Awaiting the Return of the Snake Racers
Die Rückkehr der Schlangenrenner wird erwartet
En attendant le retour des coureurs serpents
from the book:
THE NORTH AMERICAN INDIAN
THE COMPLETE PORTFOLIOS

TASCHEN

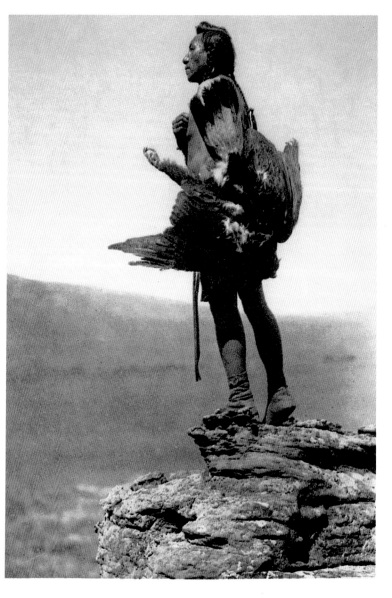

Edward S. Curtis
The Eagle-Catcher
Der Adlerfänger
Le captureur d'aigle
from the book:
THE NORTH AMERICAN INDIAN
THE COMPLETE PORTFOLIOS

TASCHEN

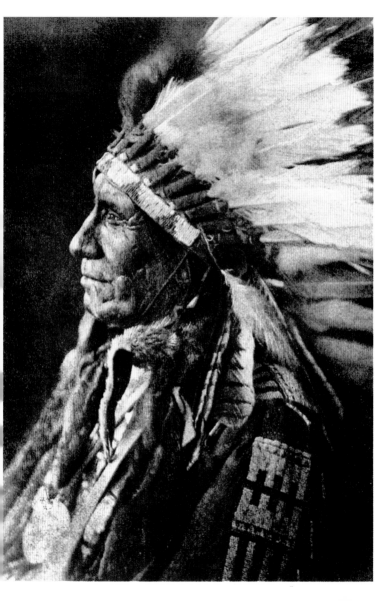

Edward S. Curtis
American Horse – Oglala
from the book:
THE NORTH AMERICAN INDIAN
THE COMPLETE PORTFOLIOS

TASCHEN

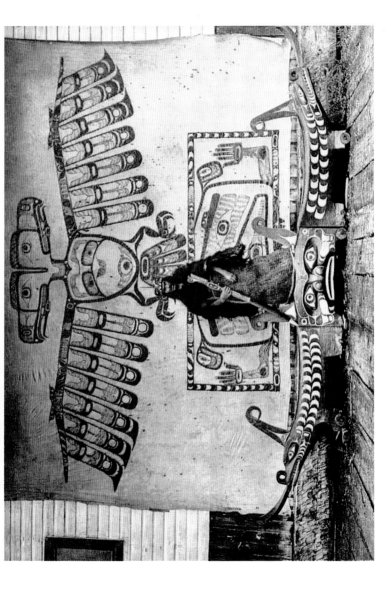

Edward S. Curtis
A Nakoaktok Máwihl
Ein Máwihl der Nakoaktok
Un Máwihl des Nakoaktok
from the book:
THE NORTH AMERICAN INDIAN
THE COMPLETE PORTFOLIOS

TASCHEN

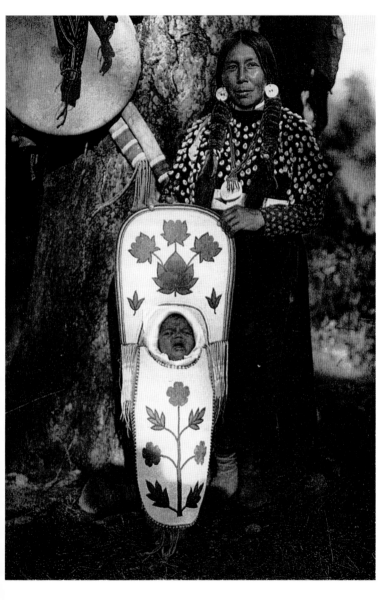

Edward S. Curtis
Flathead Mother
Flathead Mutter
Mère Flathead
from the book:
THE NORTH AMERICAN INDIAN
THE COMPLETE PORTFOLIOS

TASCHEN

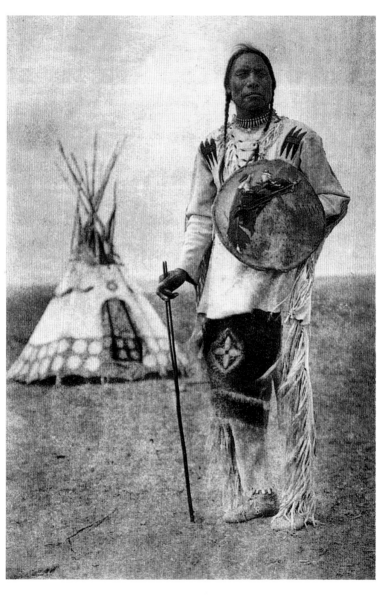

Edward S. Curtis
Akatsim-Atsissi ("Whistle Smoke") – Piegan
from the book:
THE NORTH AMERICAN INDIAN
THE COMPLETE PORTFOLIOS

TASCHEN

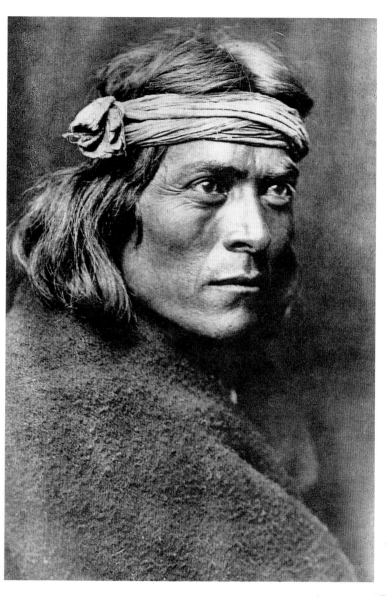

Edward S. Curtis
A Zuñi Governor
Ein Gouverneur der Zuñi
Un gouverneur Zuñi
from the book:
THE NORTH AMERICAN INDIAN
THE COMPLETE PORTFOLIOS

TASCHEN

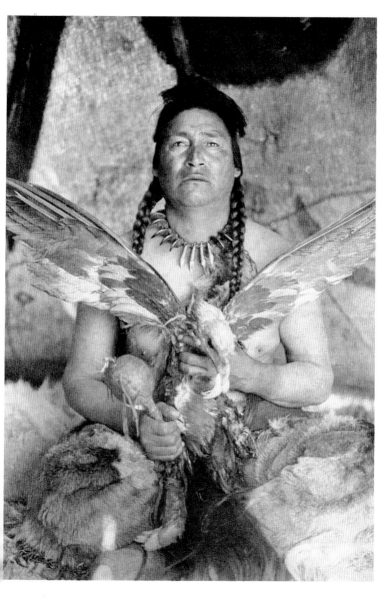

Edward S. Curtis
Placating The Spirit of a Slain Eagle – Assiniboin
Der Geist eines getöteten Adlers wird besänftigt – Assiniboin
Apaisement de l'esprit d'un aigle mort – Assiniboin
from the book:
THE NORTH AMERICAN INDIAN
THE COMPLETE PORTFOLIOS

TASCHEN

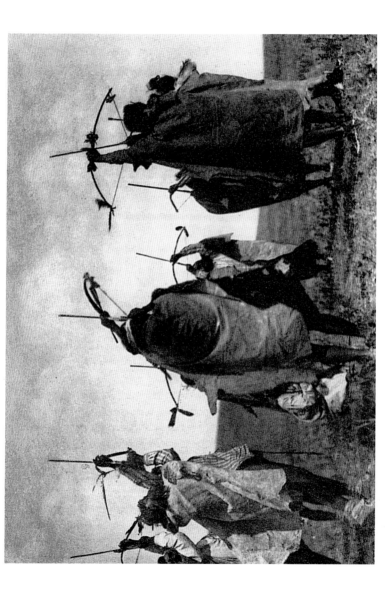

Edward S. Curtis
Atsina Crazy Dance – The Flight of Arrows
Crazy Dance der Atsina – Pfeile im Flug
Danse folle Atsina – Le vol des flèches
from the book:
THE NORTH AMERICAN INDIAN
THE COMPLETE PORTFOLIOS

TASCHEN

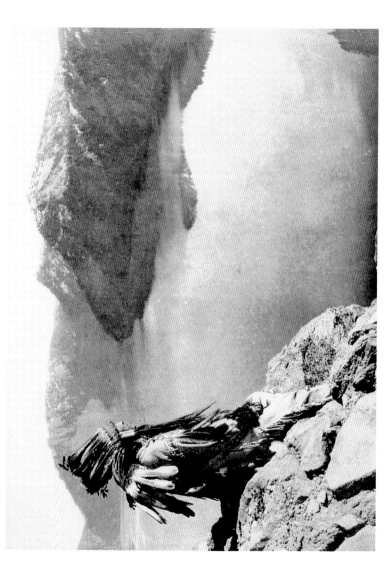

Edward S. Curtis
Crater Lake
from the book:
THE NORTH AMERICAN INDIAN
THE COMPLETE PORTFOLIOS

TASCHEN

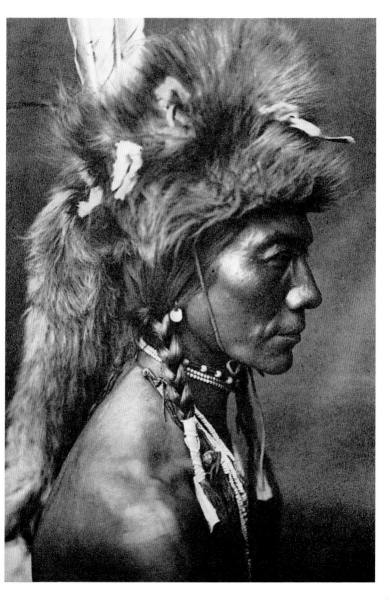

Edward S. Curtis
Yellow Kidney – Piegan
from the book:
THE NORTH AMERICAN INDIAN
THE COMPLETE PORTFOLIOS

TASCHEN

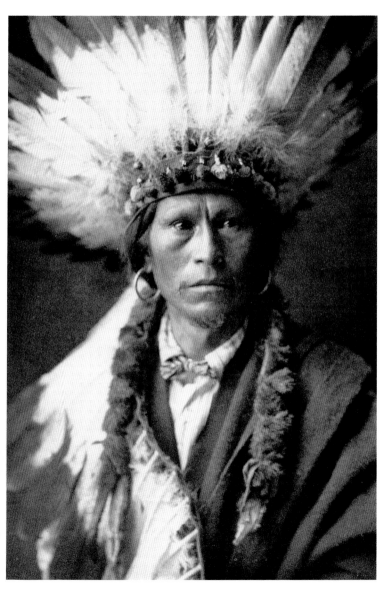

Edward S. Curtis
Chief Garfield – Jicarilla
Häuptling Garfield – Jicarilla
Le chef Garfield – Jicarilla
from the book:
THE NORTH AMERICAN INDIAN
THE COMPLETE PORTFOLIOS

TASCHEN

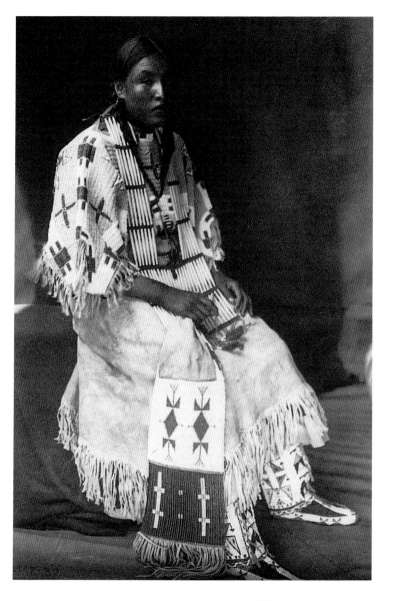

Edward S. Curtis
Sioux Girl
Sioux Mädchen
Jeune fille sioux
from the book:
THE NORTH AMERICAN INDIAN
THE COMPLETE PORTFOLIOS

TASCHEN

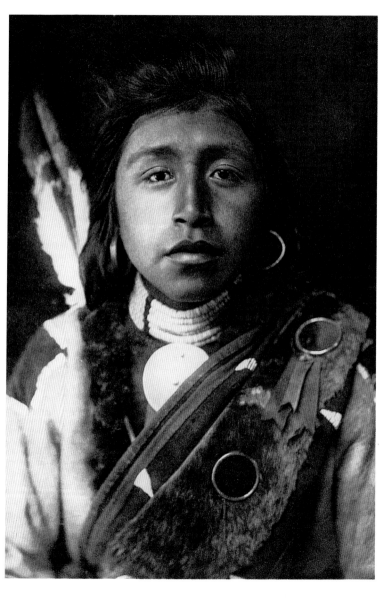

Edward S. Curtis
Káshhila – Wishham
from the book:
THE NORTH AMERICAN INDIAN
THE COMPLETE PORTFOLIOS

TASCHEN

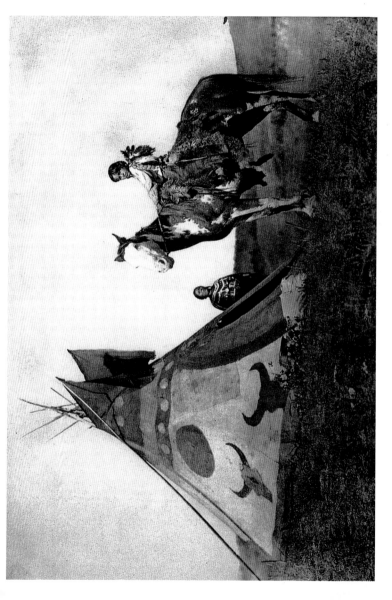

Edward S. Curtis
A Painted Tipi – Assiniboin
Bemaltes Tipi – Assiniboin
Un tipi peint – Assiniboin
from the book:
THE NORTH AMERICAN INDIAN
THE COMPLETE PORTFOLIOS

TASCHEN

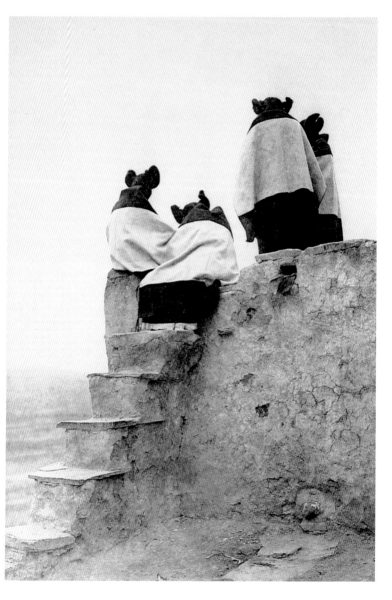

Edward S. Curtis
Watching the Dancers
Blick auf die Tänzer
En regardant les danseurs
from the book:
THE NORTH AMERICAN INDIAN
THE COMPLETE PORTFOLIOS

TASCHEN

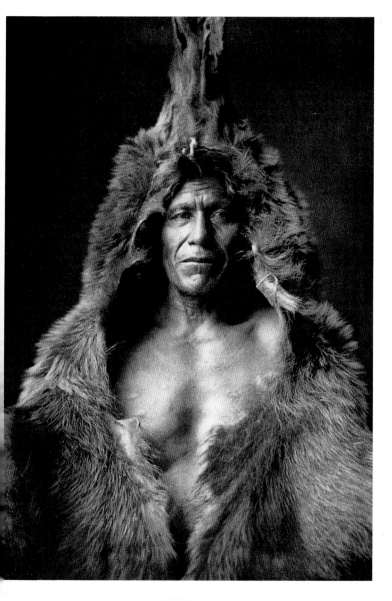

Edward S. Curtis
Bear's Belly – Arikara
from the book:
THE NORTH AMERICAN INDIAN
THE COMPLETE PORTFOLIOS

TASCHEN

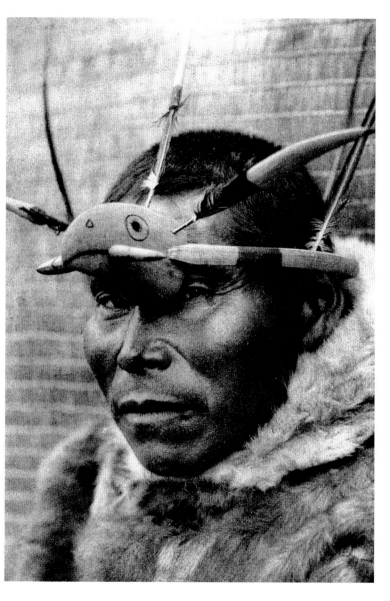

Edward S. Curtis
Maskette – Nunivak
Maske – Nunivak
Masque – Nunivak
from the book:
THE NORTH AMERICAN INDIAN
THE COMPLETE PORTFOLIOS

TASCHEN

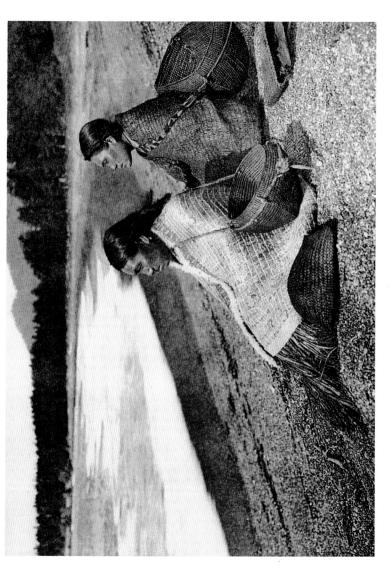

Edward S. Curtis
On the Shores at Nootka
An der Küste von Nootka
Sur la grève de Nootka
from the book:
THE NORTH AMERICAN INDIAN
THE COMPLETE PORTFOLIOS

TASCHEN

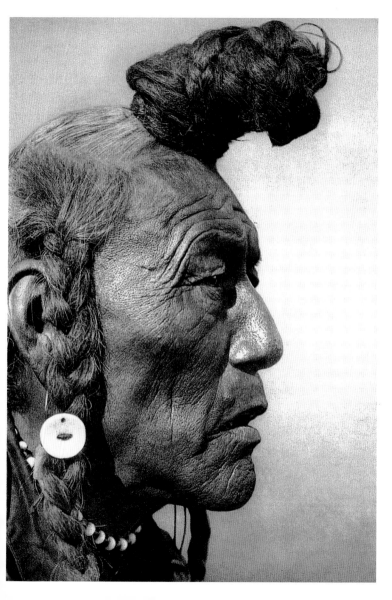

Edward S. Curtis
Bear Bull – Blackfoot
from the book:
THE NORTH AMERICAN INDIAN
THE COMPLETE PORTFOLIOS

TASCHEN

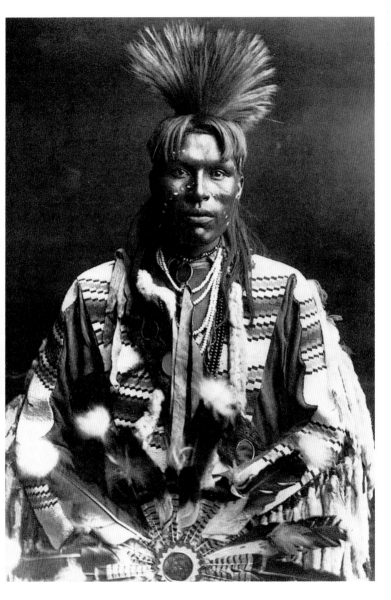

Edward S. Curtis
A Piegan Dandy
Ein Piegan-Dandy
Un dandy piegan
from the book:
THE NORTH AMERICAN INDIAN
THE COMPLETE PORTFOLIOS

TASCHEN

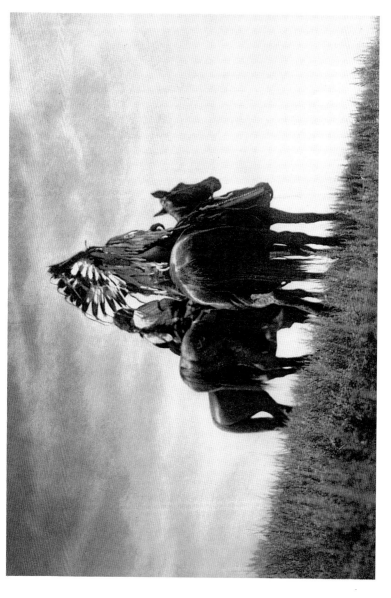

Edward S. Curtis
Cheyenne Warriors
Krieger der Cheyenne
Guerriers cheyennes
from the book:
THE NORTH AMERICAN INDIAN
THE COMPLETE PORTFOLIOS

TASCHEN